Japanese Ink-Painting

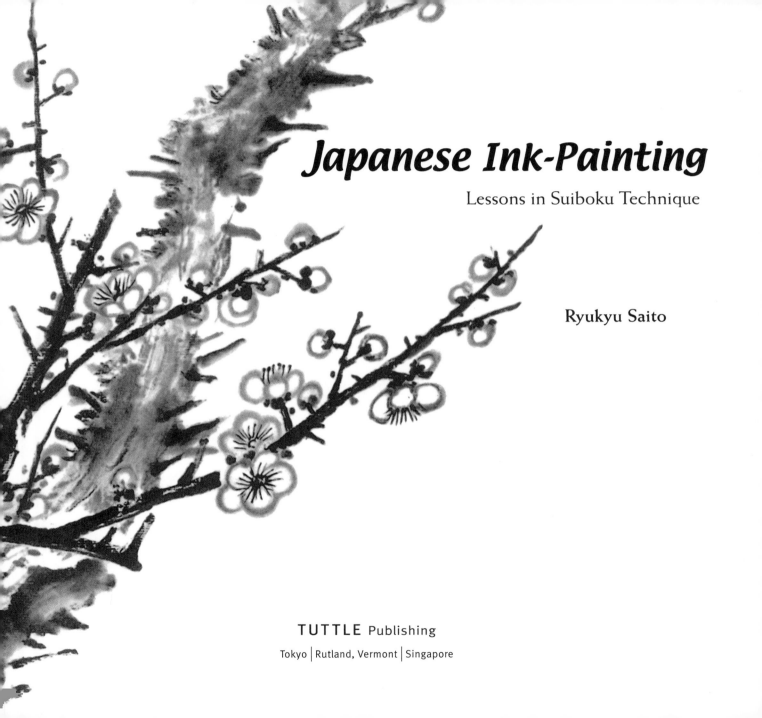

Japanese Ink-Painting

Lessons in Suiboku Technique

Ryukyu Saito

TUTTLE Publishing

Tokyo | Rutland, Vermont | Singapore

"Books to Span the East and West"

Tuttle Publishing was founded in 1832 in the small New England town of Rutland, Vermont [USA]. Our core values remain as strong today as they were then—to publish best-in-class books which bring people together one page at a time. In 1948, we established a publishing office in Japan—and Tuttle is now a leader in publishing English-language books about the arts, languages and cultures of Asia. The world has become a much smaller place today and Asia's economic and cultural influence has grown. Yet the need for meaningful dialogue and information about this diverse region has never been greater. Over the past seven decades, Tuttle has published thousands of books on subjects ranging from martial arts and paper crafts to language learning and literature—and our talented authors, illustrators, designers and photographers have won many prestigious awards. We welcome you to explore the wealth of information available on Asia at **www.tuttlepublishing.com**.

Published by Tuttle Publishing, an imprint of Periplus Editions (HK) Ltd.

www.tuttlepublishing.com

LCC Card No. 59006634
ISBN 978-0-8048-3260-1

First edition, 1959

25 24 23 22
30 29 28 27 26

Printed in Singapore 2208TP

DISTRIBUTION

North America, Latin America & Europe
Tuttle Publishing
364 Innovation Drive
North Clarendon
VT 05759-9436 U.S.A.
Tel: 1 (802) 773-8930; Fax: 1 (802) 773-6993
info@tuttlepublishing.com
www.tuttlepublishing.com

Japan
Tuttle Publishing
Yaekari Building, 3rd Floor,
5-4-12 Osaki, Shinagawa-ku
Tokyo 141 0032
Tel: (81) 3 5437-0171; Fax: (81) 3 5437-0755
sales@tuttle.co.jp
www.tuttle.co.jp

Asia Pacific
Berkeley Books Pte. Ltd.
3 Kallang Sector #04-01,
Singapore 349278
Tel: (65) 6741 2178; Fax: (65) 6741 2179
inquiries@periplus.com.sg
www.tuttlepublishing.com

Table of Contents...

PREFACE 7

INTRODUCTION (*Plate 1*) 9

1. SUIBOKU: NATURE IN NUANCES OF BLACK AND WHITE 11

2. THE PAINTER'S TOOLS 14
 The Brush: Fude 14
 The Ink: Sumi 15
 The Inkstone: Suzuri (*Plate 2*) 16
 The Paper: Kami (*Plates 3–5*) 18
 Other Equipment (*Plate 6*) 22

3. THE FUNDAMENTALS 24
 The Way of the Brush (*Plates 7-12*) 25
 The Tempo of Strokes (*Plate 13*) 32
 The Nuances of Sumi (*Plates 14–15*) 34
 The Charm of Wet and Dry (*Plate 16*) 36

4. THE "FOUR GENTLEMEN": FIRST LESSONS 39
 The Orchid: Ran and Kei (*Plates 17–21*) 40
 The Bamboo: Také (*Plates 22–25*) 46
 The Plum: Ume (*Plates 26–30*) 50
 The Chrysanthemum: Kiku (*Plates 31–34*) 57

5. ADVANCED TECHNIQUES 63
 "Broken Ink" and "Splashed Ink": Haboku
 and Hatsuboku 63
 "Without Bones": Bokkotsu 64
 "Spot and Substance": Tentai 64

6. ADVANCED LESSONS 65
 Turnip (*Plate 35*) 65

Grapes (*Plate 36*) 66
Eggplant and Cucumber (*Plate 37*) 67
Iris (*Plate 38*) 68
Pine Tree (*Plate 39*) 69
Hillsides (*Plate 40*) 70
Figures (*Plate 41*) 71
Rocks (*Plate 42*) 72
Camellia (*Plate 43*) 73
Water Lily (*Plate 44*) 74
Goldfish (*Plate 45*) 75
Shrimp (*Plate 46*) 76
Squid (*Plate 47*) 77
Trees (*Plate 48*) 78
Larks (*Plate 49*) 79
Thistle (*Plate 50*) 80
Mandarin Duck (*Plate 51*) 81
Baby Birds (*Plate 52*) 82
Tree in the Rain (*Plate 53*) 83
Magnolia (*Plate 54*) 84
Swallow (*Plate 55*) 85
Hen and Chicks (*Plate 56*) 86

7. EXEMPLARS: 87
 (1) Paintings by Classic Masters (*Plates 57–63*) 87
 (2) Paintings by the Author (*Plates 64–67*) 91
 (3) Paintings by the Author's Pupils (*Plates 68–71*) 93
 Glossary 95

Preface . . .

BY Shizuya Fujikake

Mr. Ryukyu Saito is an old artist friend of mine. In 1914 he graduated at the top of his class in Japanese art at the Tokyo School of Art, and in 1927 went abroad to the United States to continue his studies. At that time, I was on a world trip studying Japanese and world art, for which purpose I had gone from the United States through Europe and India. Since Mr. Saito was such a master of the brush, he was very warmly welcomed in the United States.

In 1927, when he was invited to take part in the New York Gallery combined exhibition of Japanese artists who were in the United States at that time, he showed some important works. President Schneider of the University of Cincinnati sent him an invitation through Dr. Tashiro, a professor of Japanese art, to come to the university. Mr. Saito was unable to accept the offer that year, having to return to Japan in 1928, but promised to come to America once again. However, the president died almost immediately after this, and unfortunately the plan never materialized.

Then Mr. Saito had an idea. He formed an International Art Association and devoted himself to acquainting foreigners with the spirit and special characteristics of Japanese art. As a result, foreigners of many different nationalities living in Japan came to know something about the techniques of *suiboku,* of which Japan can be justly proud. Acquiring a considerable reputation, he

received many requests from people who wanted to study with him, and up to the present time, he has had more than 500 students. Ryukyu himself deepened his own insight as a result, and sinking himself completely in suiboku, he decided to stand before the world as a suiboku artist. As Ryukyu says, "My feeling about the strange mysteriousness of suiboku, which is a unique form of Oriental art, is this: that what one does is express intimately and freshly the beauties of nature by means of the distinctive qualities of the *sumi* and the brush and their relation to the paper. Trying to express the sense of color by means of the operation of the sumi and the brush, I have thrown myself completely into suiboku, with the intention of boldly and freely transforming the great world of nature into pictures."

He has had several individual shows of his suiboku paintings and he has resolved to devote his entire life to this form of art. Therefore he takes great pains over every single item that he paints. He is now making a collection of his works that will serve both as a souvenir and as an opportunity to trace his development.

His many students have asked him time and time again to gather his beginning lessons together and put them into book form for the benefit of those who cannot study under him. I think this is an extremely good idea. I am giving all of my support to this undertaking, and I feel that this book will fill that need, as well as interest many others who have not yet heard of suiboku.

Tokyo, 1958

Introduction . . .

Suiboku painting is a special type of Oriental art. It is a branch or part of the general classification of *sumi-e*. Sumi-e means, literally, ink-picture. Suiboku means ink-and-water. The main emphasis in suiboku is the shading of black ink into gray—contained in one brush-stroke. The purpose of this book is to teach the beginner the fundamental technique of suiboku painting. I will try to explain this technique as simply as possible, using pictures and illustrations, so that even the amateur can learn by himself and enjoy suiboku as a hobby. The amateur should not be bound by former habits and rules but should learn to express easily and freely in individual style the feeling obtained from nature. That this spirit of expression may be reached is my sincere desire.

Suiboku painting has been enjoyed as a hobby for the amateur throughout the centuries in the Orient. The ink monochrome was recognized as an art form as far back in history as 1066. There were two general styles of these monochromes: those of professional painters, and those of the learned scholars who painted with brush and ink for the pleasure of it. These *bunjin* (men of letters) of old China were a little different from the literati of today. They were always available for service to their country as ministers or premiers, but after a crisis was over they would return to their quiet life of writing and painting. These amateurs were not bound by the standards set by the professional painters, and their paintings emphasized spirit, not technique.

This soft, liquid, gentle style is known as the Nanga school style. And as Chinese culture was diffused into Japan, the Nanga school struck a responsive note in the hearts of Japanese scholars.

The main features of the Nanga school I have taken into consideration and adapted, and now they form the basis of my teaching. After years of instructing many foreigners in the art of suiboku, I have concluded that this composite method of mine is the most suitable way for the amateur to acquire the necessary technique. As in architecture, so also in painting; a strong foundation is necessary first of all. In suiboku, the technique explained here will form the foundation. It is the fundamental rule of suiboku that I teach.

I don't think that this method of instruction is the best and only way to learn. This is merely one guide that can be used by the beginner.

I am sincerely grateful for the numerous kindnesses of many people without whose help this book could not have been published. They are Mrs. Hollingsworth, Mrs. Nishi, Dr. Fujikake and many others.

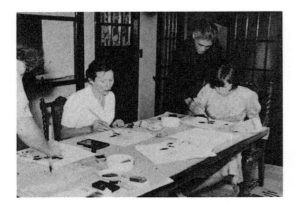

Plate 1. A class of foreign students in Tokyo.

PART ONE

Suiboku:

NATURE IN NUANCES OF BLACK AND WHITE

Suiboku cannot be readily compared to Western painting, for its techniques and its philosophy are uniquely Oriental. Although suiboku and Western water color may seem to be alike in that they both use water, actually from the point of view of technique and media they are very far apart. Suiboku is, moreover, completely unconcerned with producing a literal representation. Its emphasis is completely upon the spirit. Japanese monochromes put no emphasis on scientific or rational realism. The Nanga school, especially, aims at the representation of the state of mind, using serenity as a keynote. Thus, the most prized masterpieces are those which are thought to display a noble soul rather than an exact reproduction. Suiboku is not photography or the copying of natural things, the shape and color of which is seen with the eyes; it is the expression or the idea the artist received when he viewed the object. That is to say, it should never be an imitation but an expression of nature's impression on the artist. It should be not only external but inherent beauty that is painted. In other words, the individual conception of the individual artist should always be contained in the picture and should be expressive of the ideals and longings of the artist.

From the most complicated natural view, the artist must take the essence of the view and translate his impression of it onto paper. The artist is the means through which this essence appears in the painting.

Tied very definitely to the physical side of suiboku is the spiritual part of it. This spirituality has its basis in Zen Buddhism. Zen appears simple to understand but is very difficult to explain. Briefly, its essence is this: true knowledge cannot be imparted by words. The Zen mind, enlightened and disciplined, is able to rise above mere technical ability and goes straight to the core of being. With Zen influence, art forms try to reach the soul of the subject and show the essence of its existence. This mystic quietism was a source of comfort to the Chinese and Japanese during their times of trouble and was reflected in everything they created during those periods.

It is noteworthy that to those who follow Zen Buddhism, poems and paintings are considered as coming from the same great spiritual force. Many Nanga school paintings are coupled with a poem. As Japanese poems are usually a few words that only suggest a thought, so the paintings that accompany them are just a few lines that suggest an idea.

Simplicity of course is most important, and the Oriental mind has taken an elementary black and white kind of painting and developed a mature and sophisticated art form from it. Generally speaking, in Western paintings, black is used for its own color value. In suiboku all the true nuances of nature's colors can be expressed through shades of black. The interplay of the white areas of the paper helps develop this idea by assuming the role of the ever-present nonessential detail of the background.

To bring to life the sumi (ink) color, we have to borrow the

power of the brush. There is a Japanese word, *katsuboku*, which means "give life to sumi." The artist must be able to pass on to the one who views his picture this feeling of a living quality; otherwise, his picture is dead and devoid of meaning. This is a real goal to strive for. Because of the value of the light and dark color of the sumi, and the taste and interest which come from each variation of the brush, suiboku painting really reveals the true spirit of the Oriental people.

PART TWO

The Painter's Tools

It may be helpful to have a general knowledge about the materials used in suiboku. To the Japanese, each piece of equipment has an individual quality or attribute. I feel it is necessary for the amateur to have an understanding of these characteristics, for he is thereby enabled to express better and more easily the talent he possesses.

Four basic items are needed: the brush, the ink, the inkstone, and the paper. I shall discuss these one by one.

THE BRUSH: FUDE

The brush in Japan is very important to everyday life. It is used for writing, painting signs, etc. *Fude* or *mohitsu* are divided into two groups—*shohitsu* and *gahitsu*. Shohitsu is used mainly for calligraphy; gahitsu is used mainly for painting.

There are various kinds of gahitsu (paint brushes), big and small, long and short. These brushes are made from the soft hair of animals—sheep, rabbit, martin, badger, horse, deer. Each brush is selected according to the style of painting to be expressed. In order to draw a very delicate line we use a *menso-hitsu*. The

saishiki-hitsu is used with color. This type has a rather rounded bristle tip. *Kumadori-fude* is used for outline work. *Sakuyo* or *sengaki-fude* can also be used for outline work or for any line in general, delicate or broad. Finally there is the *tsuketate* or *bokkotsu-hitsu*. This is an all-purpose brush and can be put to any use in calligraphy or painting. It is a fairly long, big brush with firm, durable bristles. Through the years, most painters have found this brush very useful. The manner in which it was used permitted them to express freely their feelings—sometimes delicate, sometimes strong. I think this is the appropriate brush to use.

THE INK: SUMI

Sumi should be called the life of suiboku. Sumi originated in China centuries ago. China, which is sometimes called the "*kanji* (ideograph) country," has since olden times shown great development in the art of sumi-making. Sumi means both solid and liquid ink. It is not only used for practical purposes but the solid sumi has become famous as a form of art. Books have been published on the subject of sumi and *suzuri* (inkstones), and these objets d'art are held in high esteem among the literati—authors, sculptors, poets, and artists. The size of a piece of sumi varies, and the surface of the sumi can be found covered with pictures such as mountains, flowers, and birds in bas-relief. Some of the surfaces have been inlaid with silver and gold. Some sumi are so costly and beautifully done that it would almost be a sacrilege to put them to use. Many precious sumi were produced in 1573 during the Ming dynasty. Outstanding in the period were two famous sumi called *teikunbo* and *houro*.

Sumi ink is made by two methods. One method is to collect the

soot from the smoke of burning pine wood. The soot is then combined with a glue extracted from fish bones (*nikawa*) and compressed into a fairly hard cake. When ground in combination with water, it produces a brown-black ink tone. The other method uses the soot collected from the smoke of burning oil. This soot is prepared in the same fashion but when ground with water, it produces a blue-black ink tone. For painting, the more noticeable the blue tone, the better the quality of the ink.

There is a type of sumi called *seiboku* which has a high blue tone and is most suitable for suiboku painting. The old seiboku ink produced in China is highly regarded by artists of this medium. However, some of this old seiboku does not contain enough glue (nikawa), and the professional must add the proper amount of glue water as he uses it. Old seiboku is quite hard to find and is very expensive, so for the beginner the seiboku produced in Japan is adequate. Care should also be taken to be sure that the sumi is not too hard or does not contain sand or other rough material since that would damage the face of the inkstone. Such sumi is not good because the color does not blend well in water and does not spread smoothly.

THE INKSTONE: SUZURI

Before we discuss the proper use of the sumi, a description of the suzuri, or inkstone, is appropriate. The close relationship between the sumi and the suzuri cannot be divided. To grind the sumi, the face of the suzuri is needed. And from the face of the suzuri the ink develops.

The suzuri has been made from many types of hard surfaces: copper, tile, jade, quartz. The most common substance used is

sedimentary rock. Suzuri can also be divided into two groups: natural stone ones and manufactured ones. The natural stone called *tankei*, found in North China, has been valued by the literati from olden times. Famous antique suzuri are very expensive and can cost as much as $3,000. These are also regarded as objets d'art. The subject of the collections of the famous suzuri as well as sumi is too specialized to go into here. However, the antique suzuri are really a magnificent type of sculpture formed into the shape of lily pads, flowers, etc. The suzuri produced in Japan are called *Akama-ga-seki* and *Nobeoka-seki* after their places of origin. Recently, instead of natural stone, artificial stone is made from *nembangan,* a rock-like clay.

This kind of inkstone is practical for calligraphy and also for the suiboku beginner. The shape and size of the suzuri varies, but the most common one is rectangular, with the sides about 5 inches long and the surface very smooth.

Much care must be taken to grind the ink properly on the inkstone. The ink is the vital force of suiboku and is quite important. Place some water in the depression on the suzuri. Don't fill it full; a little more than half-full is adequate. Hold the sumi firmly and straight so that it will be ground evenly. As shown in Plate 2, rub around and around a couple of times on the flat surface and then into the water. Do this slowly and smoothly, not fast or with a jerky motion. If the ink is rubbed only back and

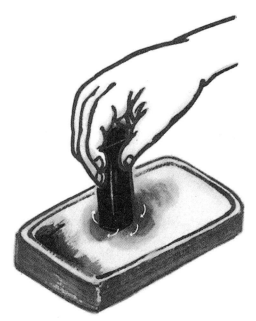

Plate 2. How to grind the *sumi.*

forth, the water and ink will not mix well and the arm will tire too quickly. To obtain the proper consistency, the ink should be ground with this circular motion for two or three minutes. The slow, thoughtful rubbing of ink on stone should produce a calm feeling and a release from tension. This is excellent preparation for the mind before the student begins to draw. This preparation of the mind of the student can be likened to the elaborate motions the Japanese *sumo* wrestlers go through before they start a match. As the artist rubs the ink, his mind is considering the painting— where to start, where to end. No outside noises distract him. Then he picks up the brush and begins. The picture should be created in one effort without loss of concentration. A suiboku picture must be completed in one painting since there can be no going back to correct or touch it up. After the picture or practice session is over, the suzuri should be carefully washed and wiped. Never use sumi from a previous session. Some established artists prefer leftover sumi, but for the beginner it is prohibited.

The Paper: Kami

The paper for suiboku is also divided into two groups; Chinese and Japanese. The Japanese paper is sub-divided into machine-made and handmade. Handmade paper is called *tesuki* and is what most foreigners refer to as rice paper. The handmade paper easily absorbs water and is the paper to use. The machine-made paper always has some degree of oil or wax in it and has a slight gloss. Therefore it is unsuitable.

Generally, for practicing, Japanese-made *wagasen* paper, or *hakutoshi,* is used. One type of wagasen paper is called *gasenshi.* The characteristics which this paper possesses make it the best for

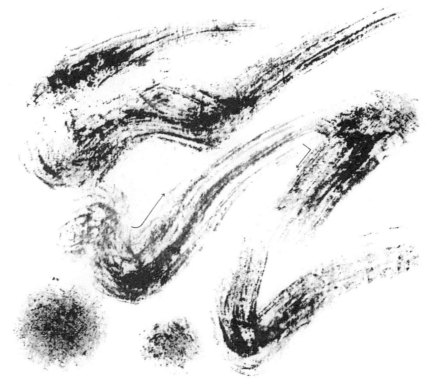

Plate 3. Kappitsu.

the beginner. It is weak and easily torn when wet, but the sumi is quickly and easily absorbed. The brush-strokes of suiboku are easily done on this type of paper. The *kappitsu* is the broken or incomplete line shown in the plum branch (Plate 3). The *bokashi* is the shading from dark to light ink contained in one brush-stroke (Plate 4). However, because this paper absorbs water so

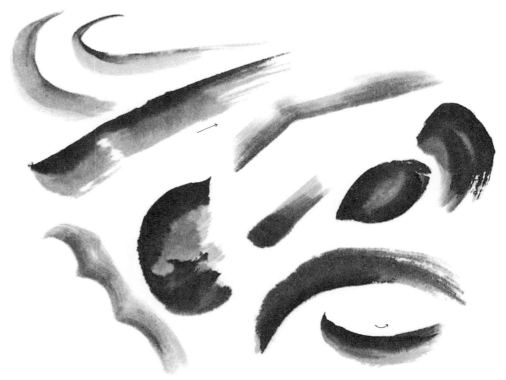

quickly, care must be taken not to cause *nijimi* to appear. Nijimi is water appearing as a halo around the black sumi and is messy in appearance. Since these features of the paper are known, the amateur knows he must draw without hesitation. Put all thoughts of self out of the mind and become one with the spirit of the picture. Concentrate on the image to be produced and draw it quickly. This is rather hard for the beginner and requires much practice. But through practice the characteristics of any paper can

20 PART TWO

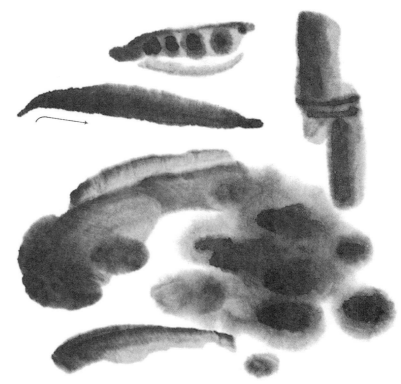

Plate 5. Nijimi effect.

be found out, and by using this knowledge, the artist can make the paper's own features help produce a picture.

I will also give the names of other papers that can be used. Each can be tried, and the beginner can find out for himself the one best suited to his talents. The price of each varies, of course, as do its features—thickness, absorption, spreading ability, etc. These papers are *gyokubansen, hosho, gahoshi, Tosa-toshi, nisoshi,* and *torinoko.*

The less important equipment is described here. In suiboku, the sumi and its shadings are the most important colors, but some touch of water color can be used as an assistant color. As a group, these colors are called *enogu.* There are three kinds: *mizu-enogu,* a thin water color; *dei-enogu,* a thick water color; and *iwa-enogu,* a very hard color cake which must be ground and mixed with glue and water. Iwa-enogu was used in the Nanga school in China. But too strong a color will detract from the real taste of a suiboku picture. For suiboku, mizu-enogu is used because it is delicate and mixes easily with water. The small box of twelve colors of mizu-enogu or *gansai,* is adequate for the beginner.

Also needed is a *hissen* or container to wash the brush. It is made of china and is divided into three sections for greater convenience. These come in a variety of sizes but the middle size is best. Also a white china plate is needed. This plate is called the palette of suiboku. On it is mixed the dark sumi from the suzuri and clear water in order to obtain the proper shade of gray. Its use is the same as that of the wooden palette used by oil painters to mix their paints.

When colors are used, another small plate must be added to the equipment. It is called a chrysanthemum dish because of the many small sections. It is used as a palette for the colors. As a matter of fact, these dishes can be brought from your own kitchen and used for the same purpose.

A cloth is needed. It is used to control the quantity of water in the brush so that the nijimi effect does not appear.

In order to keep the brush tip from harm while drying, a *fude-maki* is used. This is a small bamboo mat in which the brush can be rolled. It can be purchased in most stationery stores.

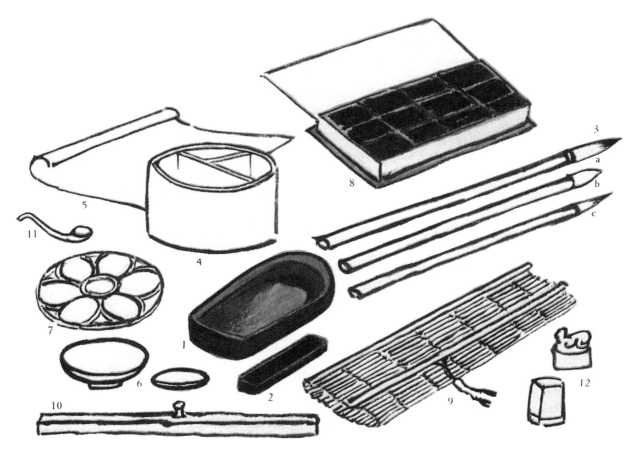

Plate 6. Equipment.

1. Stone for rubbing ink (*suzuri*)
2. Ink stick (*sumi*)
3. Some popular brushes:
 (a) for all purposes (*tsuketate*)
 (b) for color (*saishiki-hitsu*)
 (c) for line (*sakuyo*)
4. Water container for cleaning brushes (*hissen*)
5. Practice paper (*gasenshi*)
6. Shallow dish used as palette
7. Compartmented dish used for different shades of ink
8. Water colors in box (*gansai*)
9. Bamboo container for brushes (*fude-maki*)
10. Paper-weight (*keisan*)
11. Small spoon (*kosaji*)
12. Material for seals (*inzai*)

PART THREE

The Fundamentals

I have already tried to describe the difference between the materials of foreign and Oriental art, and also the difference in expression between the two. The way the brush is held and the way the ink is applied to the paper are not the same as in Western water-color art. It is desirable to set aside some time each day to the practice of using the brush with this textbook as a guide.

Just to pick up the brush and attempt to learn by yourself—to draw even one line well, without some guide—is almost an impossibility. But the technique explained here is a foundation that can lead to greater things and take the beginner over the first and biggest hurdle. It is regrettable that nowadays there are only a few people who will practice the basic technique over and over as the ancients did. It is wrong to think that only a picture of the natural object is enough for suiboku painting.

Even the great ancient painters of China and Japan had to learn the fundamentals and practice them over and over when they began their careers. After they had mastered them, they were able to develop their own style, and have left many masterpieces and original works of art for us to study. I am one who deeply believes that the brush-stroke style of the Nanga school, handed

down from olden times, is the one most suitable for the amateur of suiboku and one that gives a proper foundation. Some teachers feel that copying the brush-strokes of this school or any school is not proper, since this school shows only one way of painting among many to express the artist's impression. However, one must start learning at the beginning. The technique shown here should be used as a steppingstone to the development of the artist's own talent. To be bound by a traditional form is a great mistake, and yet copying is a good method of learning the basic rules.

The Way of the Brush

When drawing with a brush, it is important to learn from the beginning the proper way to hold and move the brush. Holding it the wrong way can ruin a line and also form a bad habit. Be careful to learn this well in order to avoid more trouble later on. As shown in Plate 7, hold the brush in the middle of the stem. If it is a long brush, three inches from the bristles will be adequate. Grasp it between the index finger and the thumb. Place the middle finger just below the index finger. This will enable you to twirl the brush slightly without losing control. Do not hold it tightly, but in a relaxed manner. At first it is normal to be tense, but a tight grip will prevent free movement. The beginner's worst faults are twofold: one is to hold the brush too tightly; the other is to use finger-and-wrist action instead of arm action. Remember that only by using the whole arm is it possible to produce the strong but light touch essential to good suiboku. Thus straight posture for the whole body is needed, and the hand and arm should always be raised clear of the paper to give sweep to the

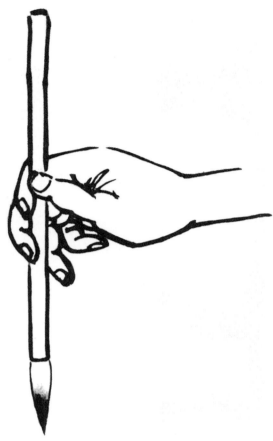

Plate 7. How to hold the brush (1).

stroke. Occasionally the left hand can be used as a rest for the heel of the right hand, but this method is used mainly for detailed lines **and is really** seldom employed.

Plate 8. Watch your posture. A straight back and free arm are required.

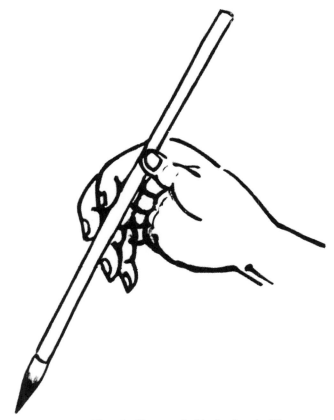

Plate 9. How to hold the brush (2).

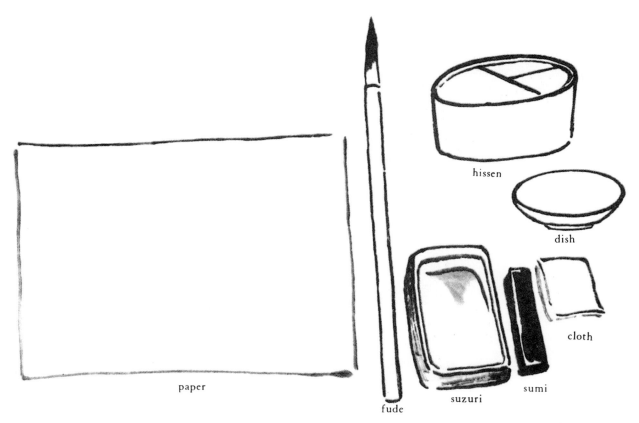

paper

fude

suzuri

sumi

hissen

dish

cloth

Plate 10. Layout of work space.

Let us have a practice session, now that you have been told how to grind the ink and how to hold the brush. Take your place at the table and spread out a layer of newspaper first. The sumi is like India ink and will stain unless wiped up immediately. Plate 10 shows a convenient way to arrange your work space.

Take your brand new brush and wash off the bristles in warm water. The bristles are protected by a thin coat of starch which has to be removed first of all. Fill the three sections of the brush-washing dish or hissen about half-full of fresh water. Place a little water in the suzuri and grind the ink. Prop the sumi on the edge of the suzuri so that it will be easily available if you need more ink and will, at the same time, dry off without sticking to any-thing.

Now pick up the brush and hold it as in Plate 7. Dip it in the water and wipe off the excess on the side of the dish. Dip the brush slightly in the sumi and rub it on the palette dish. The color to appear there will be a gray. If you want a lighter gray, add a drop more water. If you want a darker gray, add a bit more sumi. Remember, sumi is applied only on one-third or less of the bristles. The cloth is there at hand to soak up any excess water you were not able to wipe off on the sides of the bowl. (See Plate 11 for directions.)

Practice by making curved and straight lines as shown in Plate 12. Get the feel of the paper. Learn how to develop the different shades of gray on the palette and on the paper. The brush should be held between the fingers as explained before and slanted in the same fashion as you would a pencil. Be sure the elbow is raised and the wrist is off the paper. Make a few lines with the gray sumi. Do some of the strokes slowly and some quickly. Then try adding some black sumi from the suzuri to the very tip of the brush. Make a few lines. Please be observant; notice the difference in color and size as you do the practice strokes.

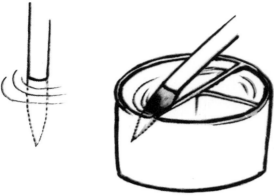

1. Dip brush into water.

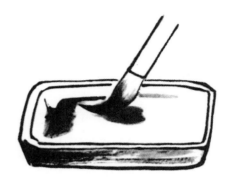

2. Dip brush into sumi.

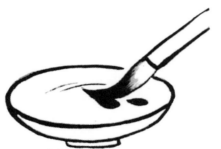

3. Use dish to remove excess sumi.

4. Wipe off water on cloth.

Plate 11. Applying sumi.

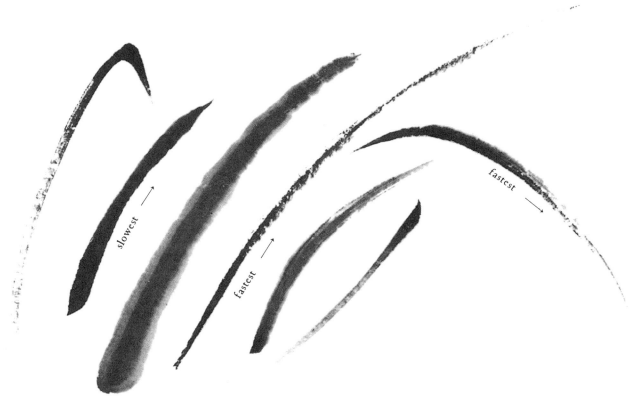

Plate 12. Practice lines showing different speeds. Brush should not be pressed down too much. Draw from bottom to top.

Next, I want to cover briefly three key points in suiboku painting that will help express clearly the artist's feeling in a simple natural manner. The black sumi appears on the surface of the white paper through a special combination of brush and ink and

paper. The general idea is that when you put brush to paper, the color will appear. However, there is a secret o special knack to this which is almost impossible to describe in words. Please try out these strokes as I describe them, and my meaning will become apparent. The three important points to keep in mind are speed, dark and light color, and wet and dry color.

Think of the picture you want to draw as of a melody drawn on white paper. The black ink is the medium by which the melody is seen instead of heard. If the lines are drawn with the same speed, the melody will be monotonous. Each tune and picture is individual. As in music, color and brush-stroke make a perfect combination and a wonderful rhythm. It is difficult to explain in words the effect of the change in color caused by the speed of the brush. The understanding develops only through repeated practice of simple, flowing lines. That is one reason for the importance of daily practice. A complete understanding of what the tools and equipment already described can do is necessary before the amateur begins to compose a picture. Not only is this knowledge important, but the object to be painted should be understood. Think about it. Is it delicate or stiff? How does the light strike it? Study it first in detail and use this textbook as a reference to see what type of line expresses the object. Compared with the practice work already done, the degree of speed of the line will be evident. The leaf of the orchid is a good example of change of speed. A rock should be black and strong and quick. Flowers are delicate, light and smooth. Trees, depending on the season and species, are light and quick or dark and strong.

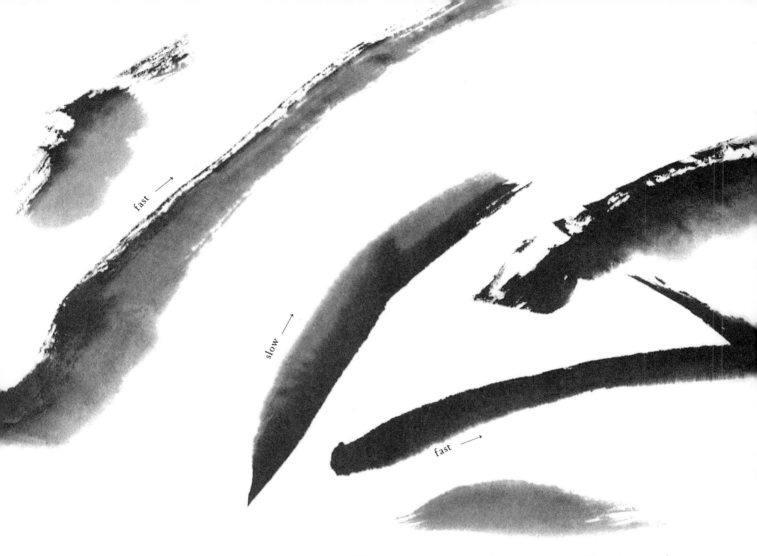

fast →

slow →

fast →

Plate 13. Example of a slow-fast stroke. The change of
speed is also accompanied by a slightly decreased pressure
on the brush as the fast part is drawn. Practice hard.

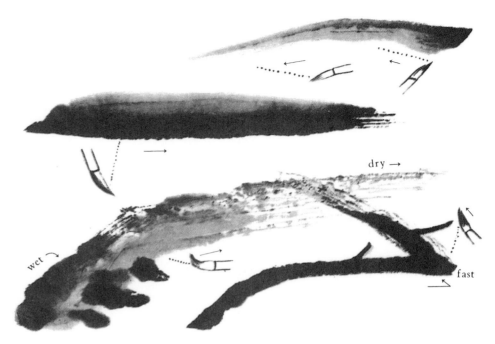

Plate 14. The main branch is done with one brush-stroke—gray color except just on the tip and side. The whole of the bristles is used in this drawing.

THE NUANCES OF SUMI

Feeling for an object is shown by speed as well as by dark and light color. And it will appear on the paper as a natural combination of dark and light, wet and dry. This gives a harmonious effect and expresses the feeling of far and near, strong and weak. Thus the sumi gives a charming color tone and a three-dimensional or cubic delineation to the finished picture. This is the katsuboku mentioned before—to give life to sumi.

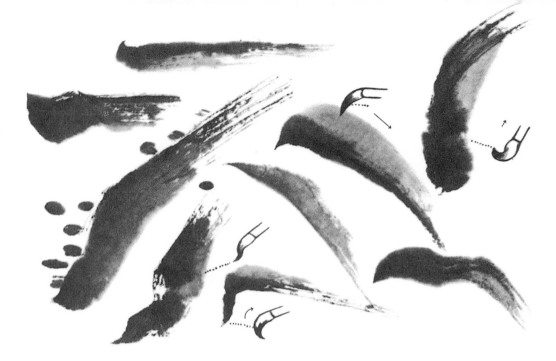

Plate 15. In these short strokes, notice the shading in each one. The brush is pointed, and the tip is placed on the paper and pressed down slightly to the side in order to form the triangle. Pull the brush along and lift it up quickly at the end to form the end of the leaf.

The knack of making dark and light colors depends on the degree of water mixed with the sumi ink on the small dish palette. It is not good technique to start with a light line and add black color to one side of the brush stroke. This has a dead effect and destroys the inherent charm. The brush should hold a light gray color, and black is then added to the tip of the brush. In this manner, one brush-stroke will hold a vast range of color tones from black to light gray. This is the foremost characteristic of

suiboku painting. There is no better technique than showing in a single brush-stroke the harmony of dark and light.

The Charm of Wet and Dry

This brush effect is more complicated than the former two. A wet brush drawn slowly across the paper will give a nijimi effect —the paper will be too wet and the ink will be fuzzy and will run slightly. When speed is added to the wet brush, an unexpectedly beautiful color tone can appear without nijimi. A wet, pale mountain can absorb a charming black tone or highlights as more black is added. This technique must be practiced in order to understand it fully. Don't forget that different paper will have a different effect on the speed of the brush and the wetness needed.

When the brush is used continuously without being dipped into the sumi or the water, or when it is blotted on the cloth, a dry brush-stroke appears. This too will give a special taste to the painting and a harmony of change. A black, dry line and a light, dry line compliment each other.

Any and all of these points should be used interchangeably with one another, and all should be used to some extent in each picture. If the amateur can understand the use of dark and light, slow and fast, wet and dry, then he can put a variation into the picture which will give it a profound depth. If this knack is neglected, even if the shape and outline and composition are perfectly done, the harmony of the whole will be spoiled, and even a perfect form will be lacking in taste because it will not have a vital quality. Each brush-stroke must be a living line with the spirit of the artist in it.

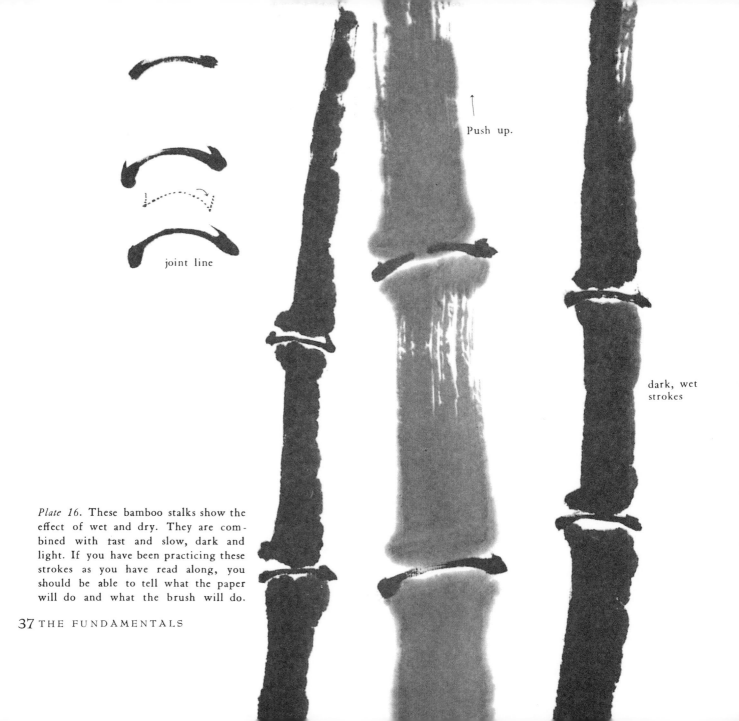

Push up.

joint line

dark, wet
strokes

Plate 16. These bamboo stalks show the effect of wet and dry. They are combined with fast and slow, dark and light. If you have been practicing these strokes as you have read along, you should be able to tell what the paper will do and what the brush will do.

The above-noted points should be kept in mind for all suiboku paintings in general. I will describe in more detail how to apply them as I show the technique used in painting each picture in the textbook.

To learn the technique of suiboku painting, first practice the pictures of flowers, trees, and small birds shown in a simplified stroke in this textbook. After you master these, generally the next step is to copy pictures done by great masters. This will increase your ability.

PART FOUR

The "Four Gentlemen":

FIRST LESSONS

From the Nanga school of old China there comes a tradition important to Oriental painters. The first pictures to be painted are usually the orchid, bamboo, plum, and chrysanthemum. The orchid gives the beginner a fine opportunity to practice line drawing of the leaves and develop the knack of free-arm movement. The bamboo shows how to use the brush in short, vigorous strokes. The plum is more involved, requiring both line drawing and a thick stroke for the branch and also giving the beginner a chance to try out the wet and dry techniques. The chrysanthemum, of course, is the hardest of the four. It combines all that was taught in the first lessons and brings in the technique of shading, which is most important.

These four plants obviously involve learning the technique from the basic line up, in the order of difficulty. But there is another reason why they are chosen for the first lessons. This is their relation to Chinese literature. In the writing of the *bunjin* (literary men) these four plants are considered true gentlemen, and in each one a different quality of a gentleman is foremost.

The orchid is compared to a gentleman of noble virtue because of the fragrance of the flower, while the bamboo is suggestive of

a retainer known for his integrity. The plum, because of the pure white blossoms, symbolizes a man of character, and the chrysanthemum is thought to represent a modest recluse because it blooms almost unseen in the foliage.

These *shi kunshi* or "four gentlemen" are the four fundamental suiboku subjects. Each has a different, elegant aspect and is expressed by a different type of stroke. As I have said before, the important thing to remember is not only to paint the object but to impress the viewer with its spirit.

THE ORCHID: RAN AND KEI

The *ran* or orchid is the first of the "four gentlemen." There are many different orchids. The ones native to Japan which I will draw are of two kinds. One has only one flower on each stem; the other has many flowers on one stem. The plant which has many flowers is called *kei*. It is noble and graceful and has a wonderful perfume. Though the petals are small, the perfection of form and odor is, to me, superior to that of the Western orchid.

Plate 17 is a line drawing of an orchid showing what it looks like in real life. Now we must draw it subjectively. Since most of the picture is composed of leaf strokes, it will be well to begin there. After the ink is made up and the supplies are all out and ready, put black ink on the brush and draw the first leaf. Start from the bottom of the paper and extend the leaf to the side of the page. Gradually let the leaf curve around to the right and apply pressure to the brush, first heavy and then light. At the same time the pressure is applied, the stroke should be slow; as the pressure becomes light, the speed of the brush is faster. This

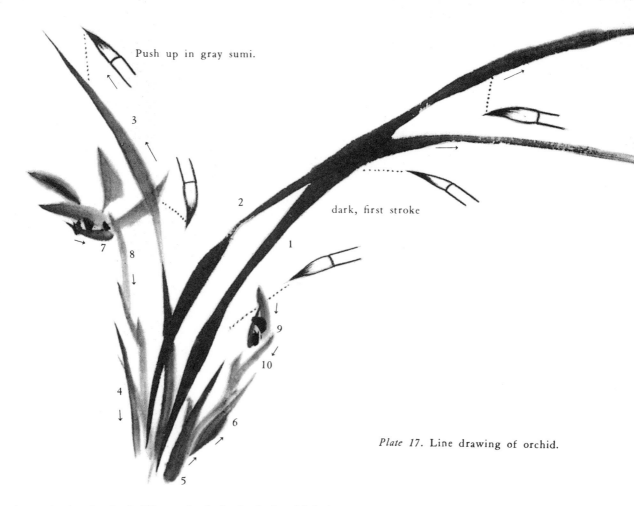

Push up in gray sumi.

3

2

dark, first stroke

1

7 8

9

10

4

6

5

Plate 17. Line drawing of orchid.

will show the twist in the leaf. The end of the leaf should fade away as you approach the edge of the paper. If there is too much water in the brush, the color will spread (nijimi), so be careful. In one stroke, draw the first leaf without hesitation. The second and third leaves are done the same way with a slight change of

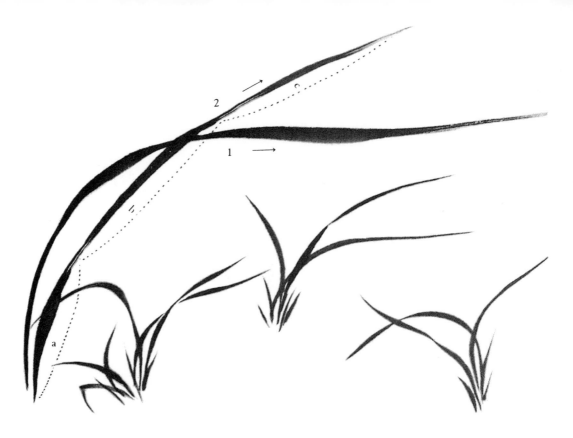

direction. Don't make the lines stiff. Vary the combination of speed and color, and draw in the other leaves each with one stroke.

As you can see from Plate 17, the fourth leaf starts at the left of the page and sweeps down into the center of the plant. Add the little leaves to your own taste to complete the plant. When they are finished, begin on the petals. Use a weak color of sumi on the brush, and on just the tip of the bristles put a little black sumi. Draw the petals quickly with a light pressure and give the

Plate 18. Orchid leaf. Start with 1 and follow the arrows for the direction of the brush.

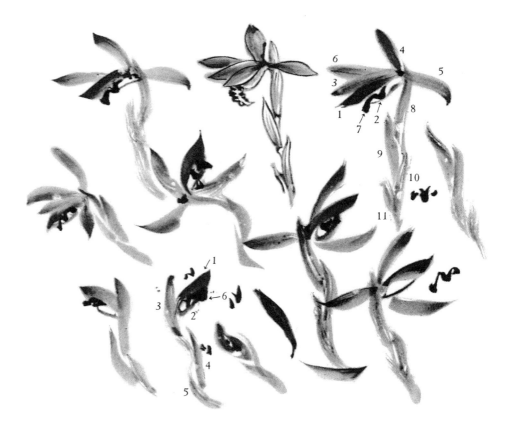

Plate 19. Line drawing of orchid flowers and buds.

brush a little twist of the wrist as you draw. Don't use the same side of the brush each time. If you have applied the sumi properly, the tip of the petal should be black and the rest a little lighter gray. Next, fill in the pistil of the flower with very black sumi. Plate 19 shows a line drawing of orchids with the flowers and buds facing in different directions. In this plate there is a stroke-by-stroke drawing of a flower. Start at number one and continue

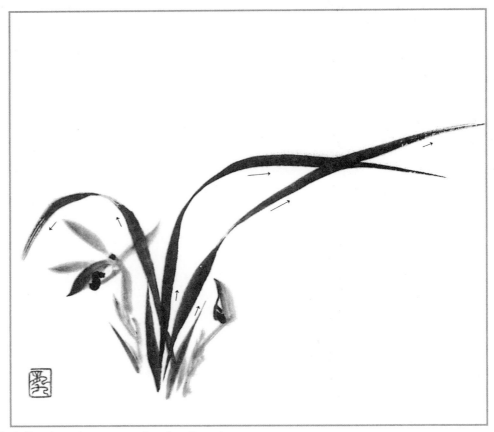

Plate 20. Finished orchid.

in the order indicated, following the arrows for the direction your brush should follow. Please notice how the tips of the petals are shaded. These are not touched up. It is possible to do it with one stroke if you do not add too much sumi to the very tip of the bristles.

Last is the stem; draw it quickly with light sumi. It is important to remember to show the entire petal or leaf in one brush-

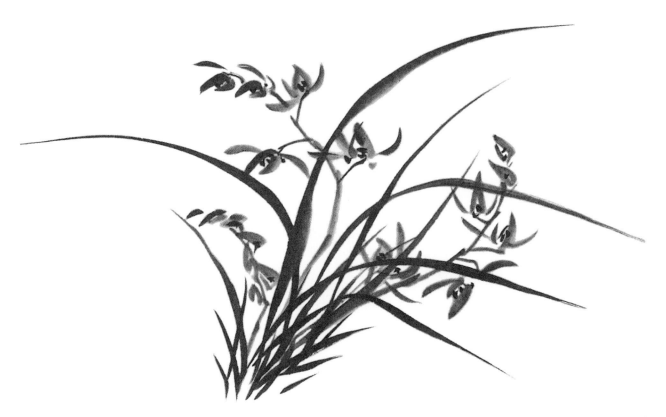

Plate 21. Kei.

stroke. Don't outline the leaf or petal and then fill in the shades of gray. If you hold the brush too tightly, the line of the leaf will look like a stretched wire, so be relaxed.

Plates 20 and 21 show the finished pictures of the orchid. The first shows a single flower and the second is the many-flowered orchid called kei.

THE BAMBOO: TAKE

There are many varieties of bamboo and they have many names. *Moso, madake,* and *tanchiku* are the most common. The one I shall explain how to draw is one of the most common and can be found anywhere. Many painters have used the bamboo for the subject of their pictures, and many famous pictures of it still remain. The orchid is quite feminine as compared to the masculine bamboo and is a good contrast. The bamboo shows a strong vitality and the beauty of the straight line. In China there is a famous picture of bamboo drawn only in a crimson red. Perhaps when you study the bamboo, you will be able to understand the fresh and invigorating force the plant expresses to Oriental people. It is hard to explain the symbolism of it—enduring, strong yet pliable.

Plate 22 is a line drawing of a bamboo. We must put our impression of it on paper. Remember that it is an exercise in straight lines.

Begin with the stalk. Use light-colored sumi on the brush and not too much water. Bend the bristles at almost a right angle. Start at the bottom of the page and push upward in a straight line. Leave a space for a joint; continue; leave another space; continue; this time the brush should go off the top of the page as in Plate 23. Don't hesitate in the stroke since speed is essential. At the spaces left for the joints, use very black sumi and make a horizontal line. Curve the ends slightly so that the roundness of the stalk is indicated. Next, the smaller stalks are drawn with a light sumi. Do these quickly and lightly. Be sure your arm is free and your posture is good. The joints are done with a free-arm movement.

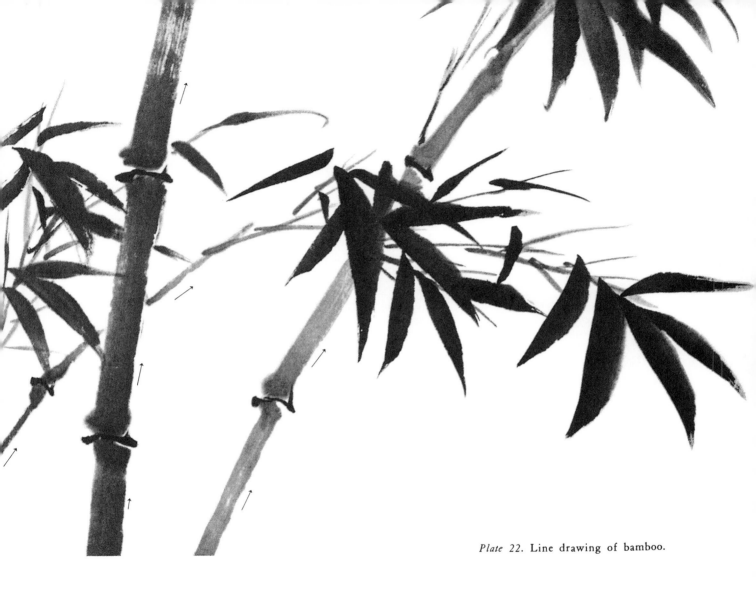

Plate 22. Line drawing of bamboo.

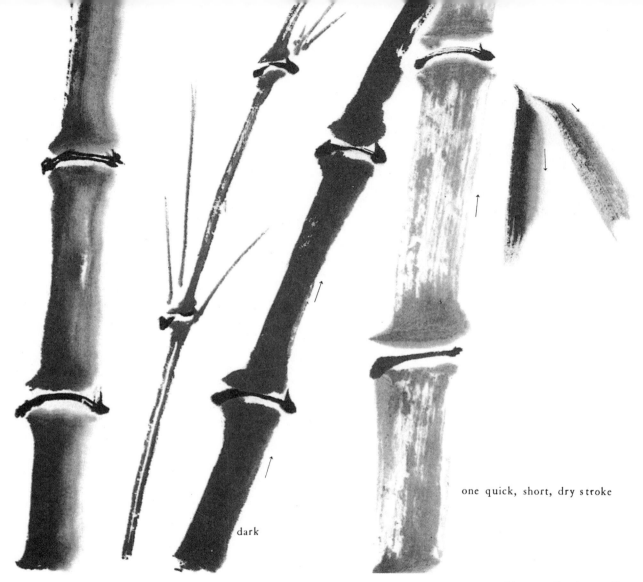

dark

one quick, short, dry stroke

Plate 23. Bamboo stalks.

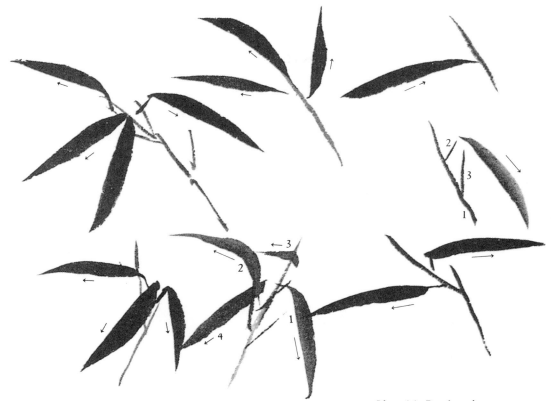

Plate 24. Bamboo leaves.

Now practice the stroke for the leaves. Point the brush and place the tip on the paper. Press the brush down and slightly to the side at the same time. Push down to widen the middle and quickly end the stroke by picking up the brush from the paper. Use a thick black sumi and draw downward and outward in one stroke. The bristles will be bent as in drawing the stalk, and the

brush rotates slightly when you begin to draw a new leaf. This movement will insure that the next leaf shows a little variation of color. The whole stroke is fast; however, each stroke contains three parts. At first, the stroke should be delicate near the stem of the leaf; the middle part is strong and wide; at the end of the leaf, make the sharp point and quickly raise the brush from the paper. Vary the color and strength of the leaves and also the length, but they should all be dark. Remember, the bamboo represents straight lines and does not curve like the orchid. If the leaves are drawn with the same length and color, they lose vitality. So study the picture to see how they lie. The distant ones are lighter, the near ones very dark. Practice this very carefully.

The Plum: Ume

There are many varieties of plum trees. The plum is the first of all flowers to bloom in the spring in Japan. It is much esteemed for its beautiful petals and exceedingly sweet fragrance. The color of the flowers ranges from white to deep pink. It is also quite a special tree in the Orient and is the subject of many poems and paintings. This tree is admired for the tree trunk rather than the flowers. The plum is important to the Japanese because they make delicious wine and pickles from the fruit.

This is a hard picture to do and is quite different from the orchid and bamboo. The trunk of the tree doesn't bend but has sharp angles. Each tree has a different shape or form, so it is hard to describe it briefly. Start with the branch, and then the twig, showing each different angle. The brush should hold a medium-gray sumi, while the tip and one side have black sumi applied to them. Bend the bristles in almost a right angle as for the

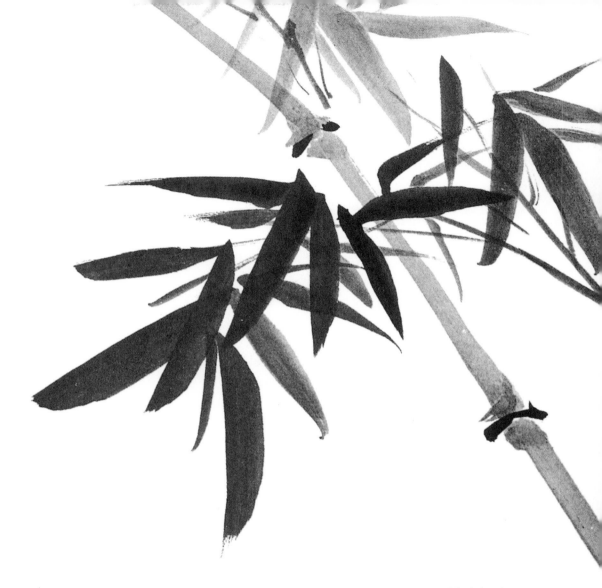

Plate 25. Finished bamboo.

THE "FOUR GENTLEMEN"

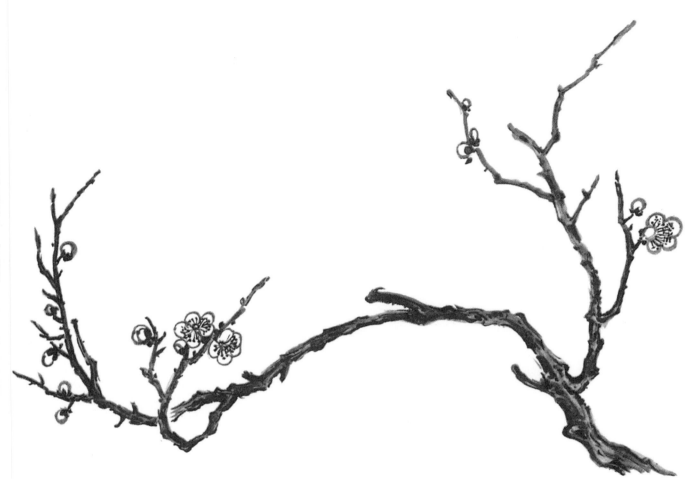

Plate 26. Line drawing of plum.

bamboo. Then touch the side of the brush to the paper and push with a slight force. The variation in color will appear naturally and the light, heavy, wet, and dry shades will express the three-dimensional effect of·the surface of the trunk. The mingling of

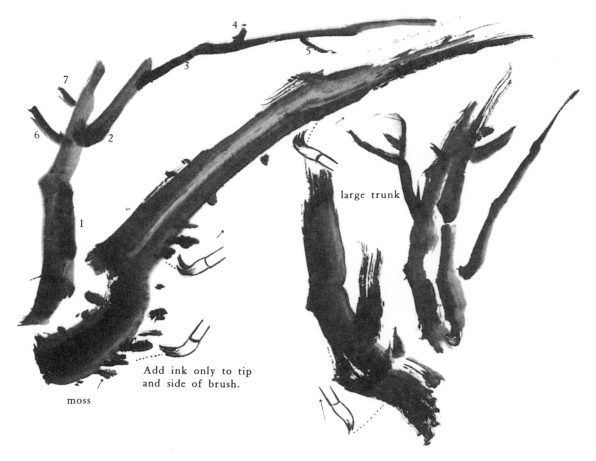

large trunk

Add ink only to tip
and side of brush.

moss

Plate 27. Plum trunk.

wet and dry, particularly, will give the feeling of the natural bark
of the tree. When black moss points are added here and there, it
will look like a very old tree. Draw the smaller branches and

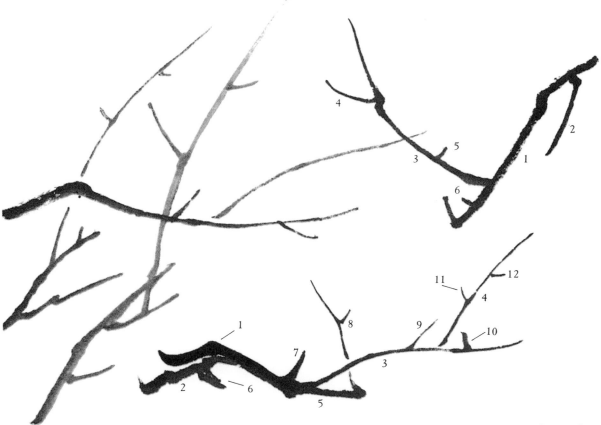

Plate 28. Plum twigs.

twigs quickly with a free-arm movement, remembering to use a light touch. Vary the color as shown. The branches combine mainly the dry and fast techniques and also stress the sharp angles natural to the plum tree. Then add the flower. The open flowers have five round petals. Wash the brush and blot out most of the water. Then with a medium sumi and a light touch, draw

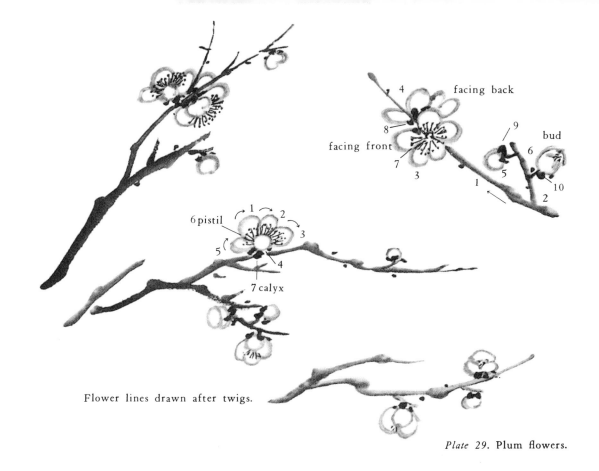

facing back

facing front

bud

pistil

calyx

Flower lines drawn after twigs.

Plate 29. **Plum flowers.**

the flowers with a delicate line. Make the style different—bud, half-open, or full bloom. Make them face in different directions too—backward, forward, or sideways. They should also be different in size. Finally, with a thick black color and a dry brush, add the pistil and calyx delicately.

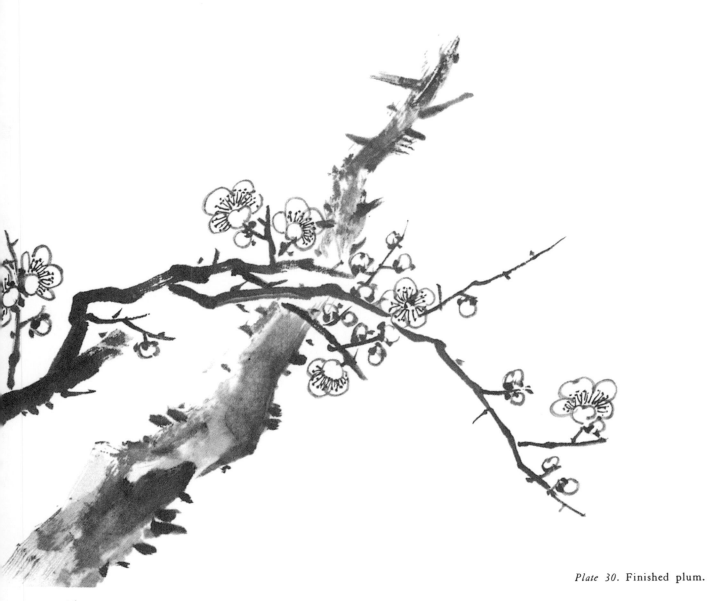

Plate 30. Finished plum.

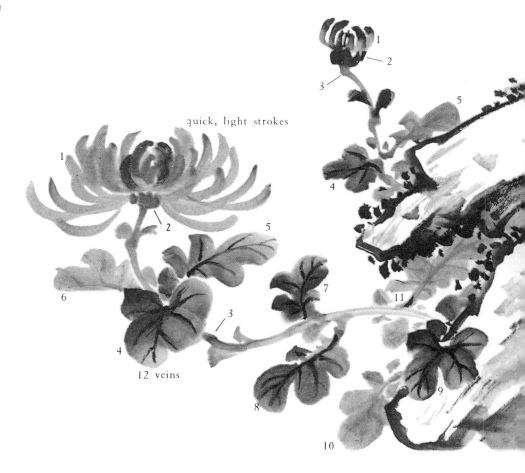

quick, light strokes

12 veins

Plate 31. Chrysanthemum (Spider Mum). Painted without outlines, in *mokkotsu* technique. Each petal and leaf made with single stroke, of very lightly held brush and with little pressure. Note "wet" leaves contrasted with drier brush-strokes in rock at right. Finally add black accents, veins on leaves, etc.

The chrysanthemum is the most popular flower used in floral arrangements in Japan. It is the last of the famous "four gentlemen". Not only are the kinds of chrysanthemum numerous, but each blooms at a different time of year, from early spring until late fall. This is a noble flower and the Emperor's family has used it in an ornamental design for their crest. It is greatly admired for its fragrance and for the beautiful shape and color of its flowers. Some are single and some double, and even the wild ones are lovely.

In color and shape this is more complicated than the plum. The petals need a drawing technique that will give depth. Since the petals are in layers, they are more difficult to draw. Start with the middle of the flower and draw the four small petals in the form of a cross facing the center of the flower. Around these add more, one after the other. The sumi should be dark and fairly dry. As you add more petals, remember the curve and the shape of the flower. Does the face turn up or down? According to the shape, change the curve and the length of the petals, making the last ones the longest. After the petals are finished, draw part of the stem with dark, slightly wet sumi. Next draw another flower. Show its feeling by the slight curve of the petals. Draw its stem to connect with the other one. At the juncture of the two stems, draw the first leaf facing front and bending down to the bottom. This one is the closest and therefore the biggest. These leaves can be the hardest to learn. It takes much practice to do them well and not make them look like ostrich plumes. It would be well to try several pages of these before adding them to the picture. The brush should hold a medium sumi with thick black on one side. Hold the brush up straight. Look at the first leaf. The first lobe is made by a push at the paper. Turn the

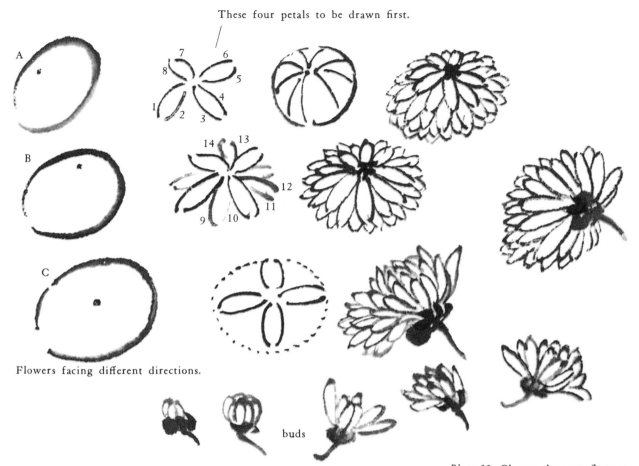

These four petals to be drawn first.

A

B

C

Flowers facing different directions.

7 6
8 5
1 4
2 3

14 13
12
11
9 10

buds

Plate 32. Chrysanthemum flowers.

brush just slightly and make the second lobe with two strokes. The next two strokes are made downward and with a little slower push. That will make the leaf fat. Next the last two lobes are made and the leaf needs only the vein marks to complete it. As leaves are added, change their color. Consider whether the leaf curls so that the back is facing outward. This can be shown by size and color. By the force of the push—heavy or light—the leaf can contain a beautiful harmony. All leaves are not straight, either; some tilt up or down. When the leaves are finished, put in the veins. Use a rather dry brush and very black sumi for this, and use a delicate touch. If the leaf is still a little wet, the black vein will blend in nicely. The technique on the leaves is very hard and when this is mastered, you can draw anything.

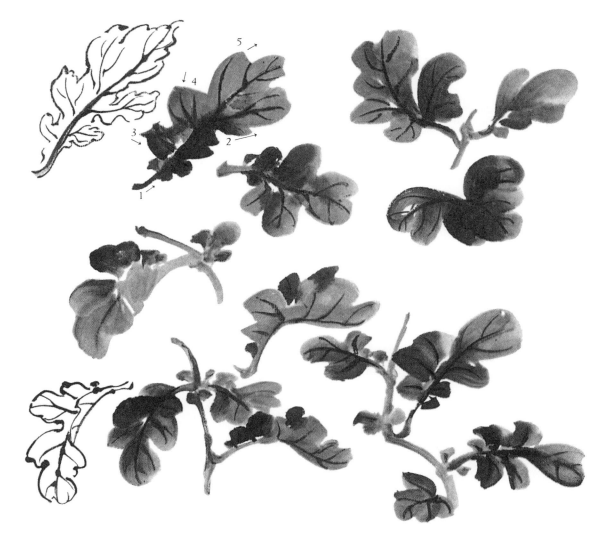

Plate 33. Chrysanthemum leaves.

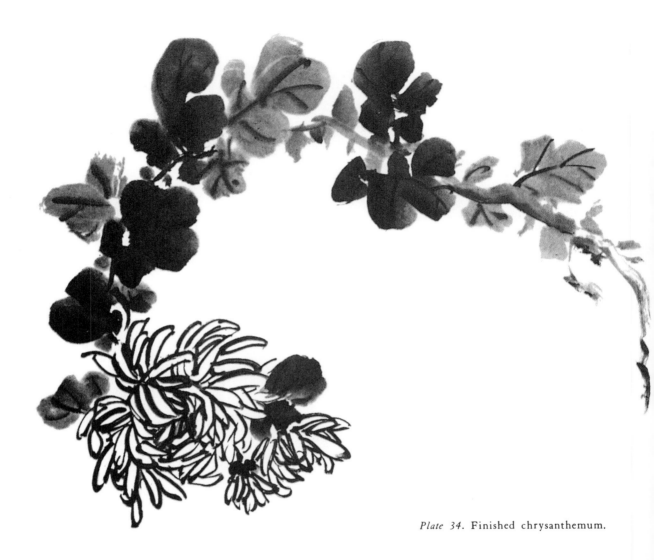

Plate 34. Finished chrysanthemum.

Part Five

Advanced Techniques

Besides the fundamental techniques taken up in the "four gentle-men" or shi kunshi, I would like to add here, for reference, some explanation of *haboku, hatsuboku, bokkotsu* or *mokkotsu,* and *tentai* techniques.

"Broken Ink" and "Splashed Ink": Haboku and Hatsuboku

These two are related terms often confused by the Japanese them-selves. *Haboku,* literally translated, means "broken ink" or an effect similar to that of dry-brush painting, wherein the brush starts out rich and black, but gradually grows dry until the bristles separate and leave areas of white. The Chinese painters called this very desirable effect "flying white", since it yields an impression of speed and movement. An example is seen in Plate 57 by Sesshu.

Hatsuboku, literally translated, means "ink splashing forth" and should designate a sort of wet, quick, and splashy effect.

In common usage these terms are often confused and are used interchangeably. Both aim at a lively, dynamic quality with full range of all tonalities from black to gray and to white, and since

the painting is done with rapid movement, the result is also brimming with liveliness and a sense of speed.

"WITHOUT BONES": BOKKOTSU

Bokkotsu or *mokkotsu* literally means "without bones" or without any outline drawing. In this technique the brush is wet and full of ink, so that an entire leaf, eggplant, or similar form can be painted with one rapid stroke and without re-dipping the brush. After the first large form is indicated, the addition of interior lines, veins of leaves, stem, etc. may be made after the ink is at least semi-dry and ready to receive these accents of a much deeper, drier black.

The same method is also used in painting with water colors for petals of flowers, etc. (See Plate 31.)

"SPOT AND SUBSTANCE": TENTAI

This is a technique of creating large forms like mountains or treetops by a close juxtaposition of inkspots in a method that seems superficially related to "pointillism." Literally translated, *tentai* means "spot and substance," and its use is traced back to the famous Chinese painter, Mi Fei (1051–1107), whose work is seen in Plate 61.

In practice, the point of the brush is placed horizontally on rather damp paper, and closely packed oval dots are allowed to overlap when a darker area is needed. The resulting forms are rather soft and foggy without sharp outlines.

PART SIX

Advanced Lessons

In this section I have included some of my more advanced lessons. If the student has practiced hard, he should have no difficulty in applying his newly acquired technique to the following pictures. These should be used only as further practice, and the artist should be able to do many suiboku pictures of his own.

Good luck, now that the career of the suiboku artist has begun!

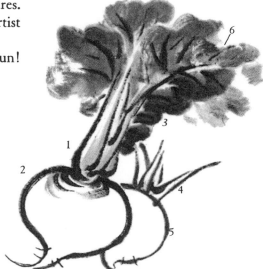

Plate 35. Turnip. Paint like the chrysanthemum leaf, but watch the shading in it. Use the vein as an accent.

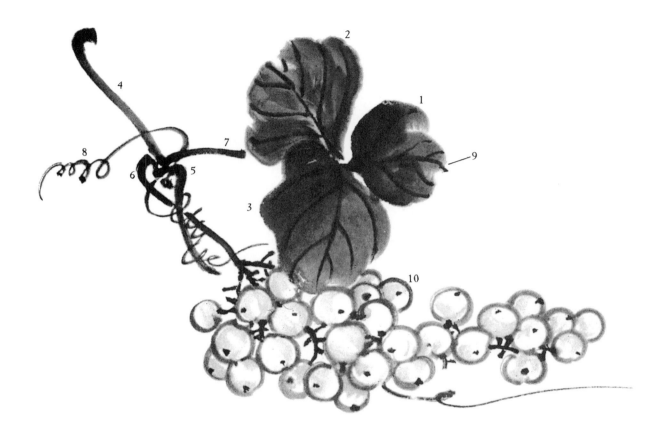

Plate 36. Grapes. Begin with the leaf. It takes three strokes to make the upper left lobe of the leaf, three for the bottom, and three for the right side. Use the same technique you learned on the chrysanthemum leaves. Draw the main stem and then the fruit. The grapes are easy—just a drawing technique—but you should vary the color of the sumi and the size. With dark sumi add the little stems between the grapes.

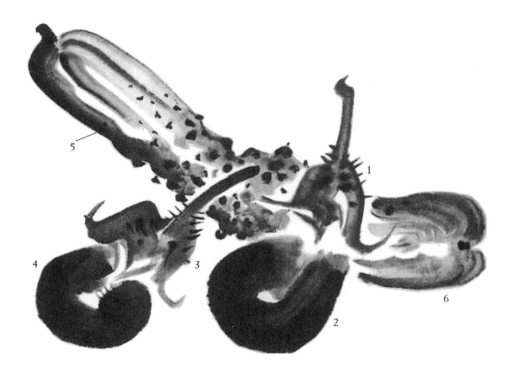

Plate 37. Eggplant and cucumber. The body of the eggplant is very interesting. It is made with one stroke of the brush, turning it so that the tip of the bristles makes a circle. You can see that very black sumi is used, and just a few brush-strokes complete the rest of the eggplant. The cucumber needs attention to the shading around the edges to give it the three-dimensional effect. The knobs on the cucumber are applied in the same way as the moss on the plum.

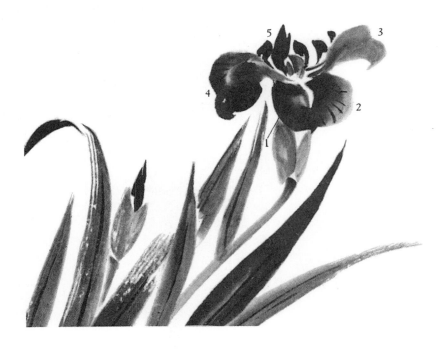

Plate 38. Iris. Brush is carefully loaded to yield each petal in a single stroke. Use damp brush with strongest black at tip and one side. Twist brush around to conform to curve of petals; try to obtain gradations of light-dark in a single movement.
Leaves. Pull brush up from bottom; paint darkest color first; and let leaves grow paler as ink is drained from brush. Finally, add dark accents.

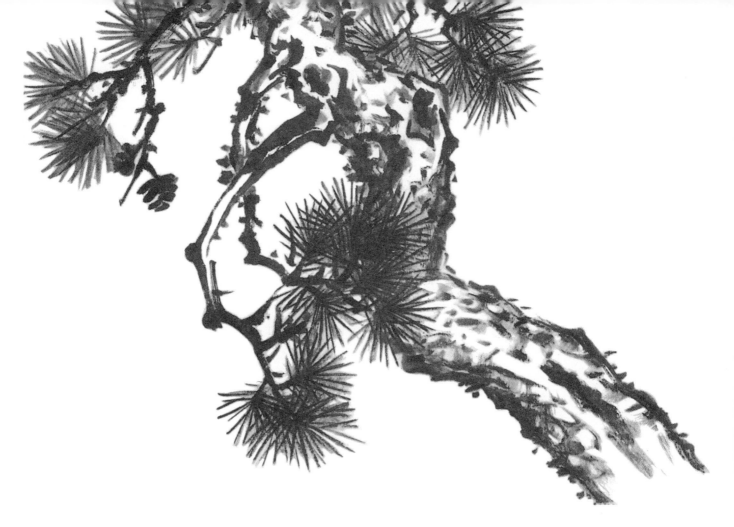

Plate 39. Pine tree. The trunk is done first in a light sumi. It is not outlined but rather suggested. Then with a darker sumi and a drier brush, add the heavy lines that signify the rough bark. The branches and the short strokes that show the pine needles are added. These lines are all very short and brisk, and show vigor and strength.

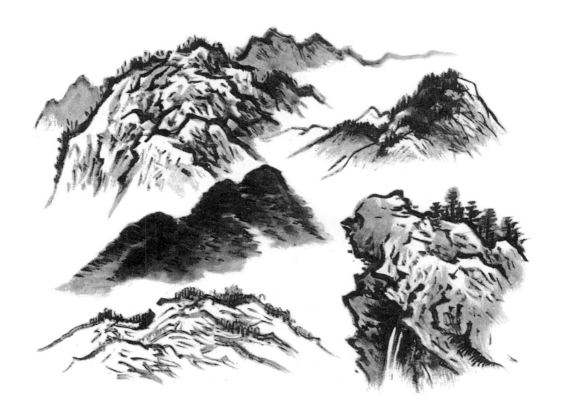

Plate 40. Hillsides. The hill at the middle of the page is painted with a wet technique. With a fairly wet brush, block in the outline of the hillside. Put black sumi on the tip of the brush and lay it sideways along the hills that you want accented. The black blends in with gray very tastefully, but don't get it too wet or nijimi will appear and leave a water ring after it dries. The effect of juniper trees on the hill at top right is obtained by holding the brush in upright position and using only the tip. The hill at bottom right has brush-strokes to represent pine trees. Do the rough sketch with light sumi. As the picture takes shape, add the blacker accents. Then as the picture dries, you can add the vivid black marks with a very black ink and a dry brush.

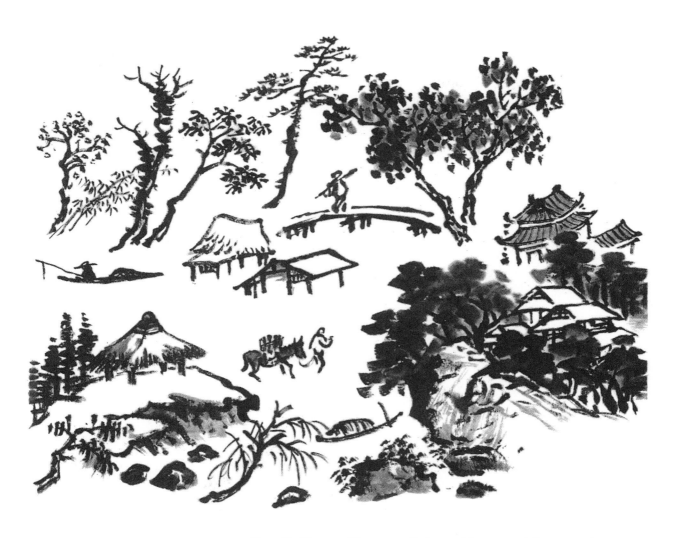

Plate 41. Figures. These are all done with a very delicate touch. This is one time you can prop your hand on the other to draw. Don't push hard or you will not be able to get a thin line.

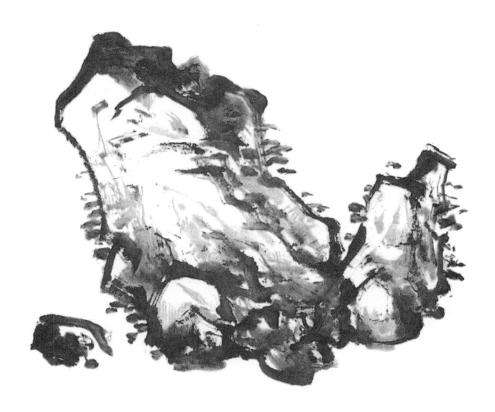

Plate 42. Rocks. Feel the main outline (start at left side, moving up, over top, then down) and paint this with twisted brush to obtain variety of line and width in single stroke. Dip brush into water after each stroke for paler areas; then use sumi again for dark, sharp outline of next form. Interior details come last. Aim at greatest variety of sharp-angular and curved-soft effects. This painting sums up almost all technical skills in suiboku.

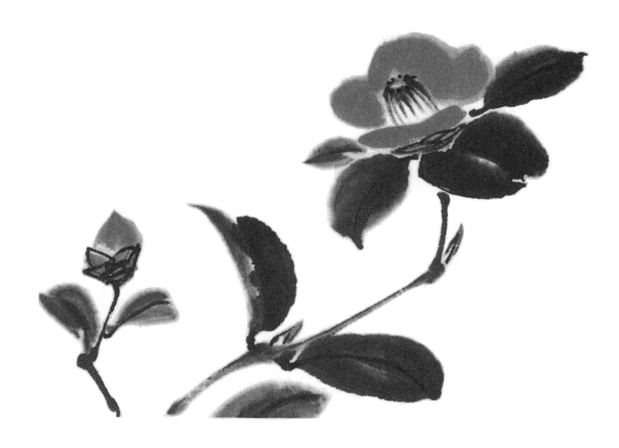

Plate 43. Camellia. Shows combination of black ink and water colors. However, two or three colors in one picture are enough.

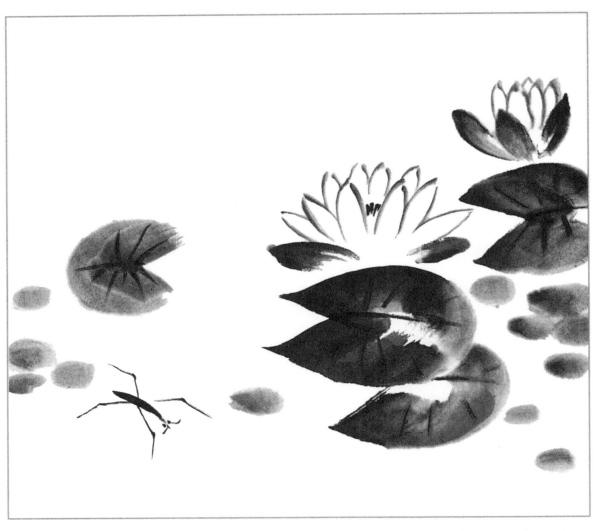

Plate 44. Water lily. Exercise in brush-stroke variety : line and area, wet and dry; use tip of brush for petals, side of brush for leaves.

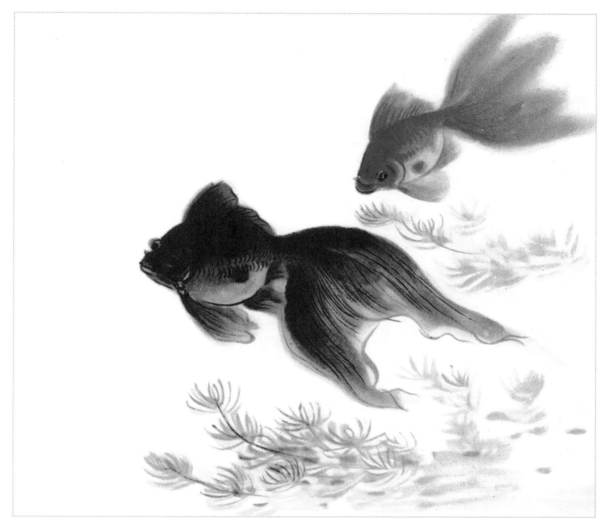

Plate 45. Goldfish. Another example of the use of color.

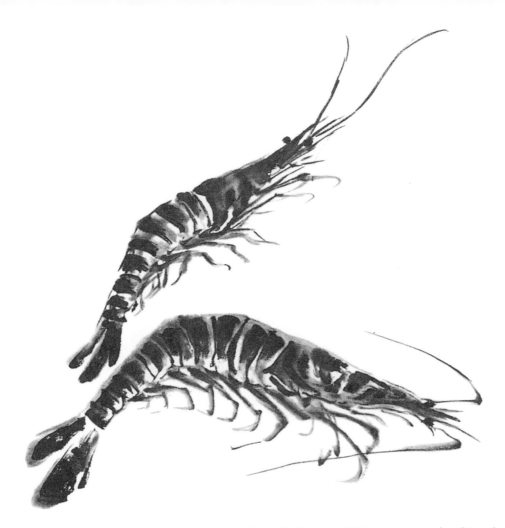

Plate 46. Shrimp. With a very pale, faint line indicate barely visible outline of both shrimp, merely for placement in composition. Then with bold black, work from the eyes and head backward, showing each scale of the armor separately. Later, before ink is entirely dry, place light wash over whole creature.

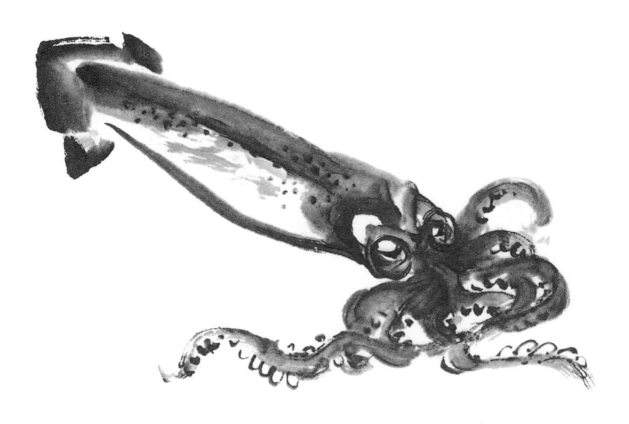

Plate 47. Squid. Long, wet strokes create the body; then small, sharp strokes are added for detail.

Plate 48. Trees. Trees of various species in color.

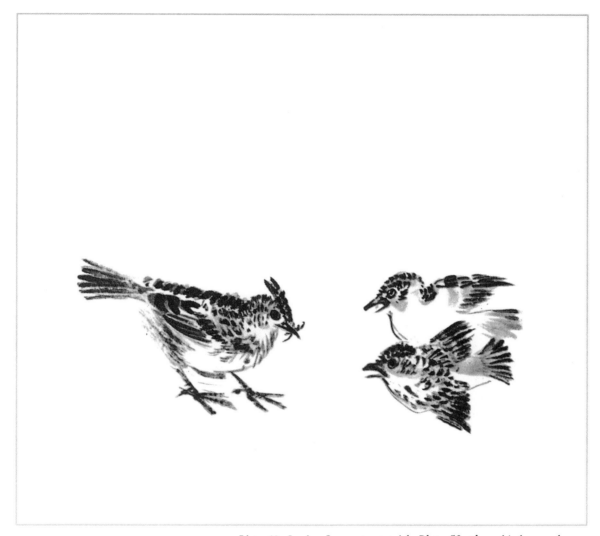

Plate 49. Larks. In contrast with Plate 52, these birds are shown feather by feather, rendered with short strokes of tip of brush.

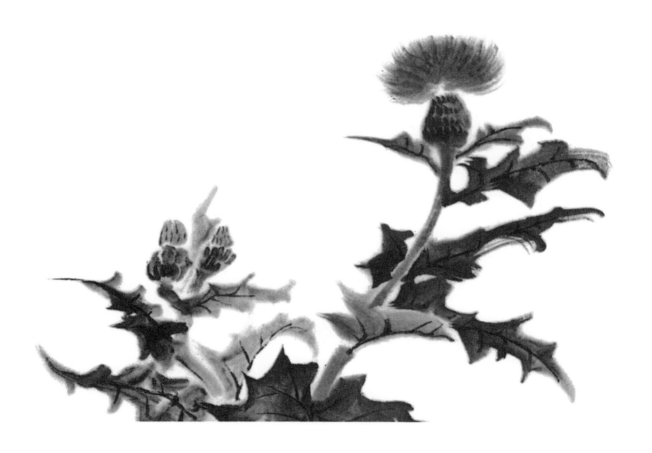

Plate 50. Thistle. Painted with wet, side strokes for leaves, with veins added later.

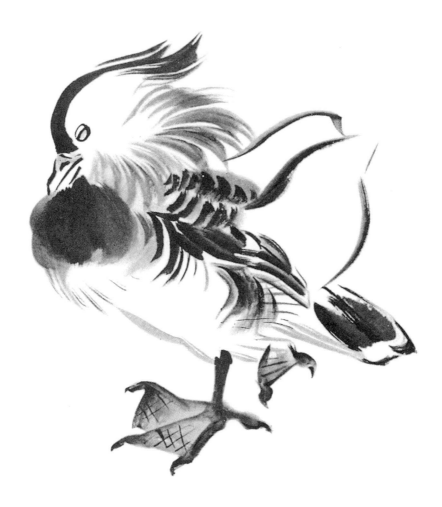

Plate 51. Mandarin duck. Complex design bringing together many aspects of technique of line and ink gradation, and of different speeds and rhythms in strokes. The changing ink values, from pale gray to black, suggest the different colors of this bird's plumage.

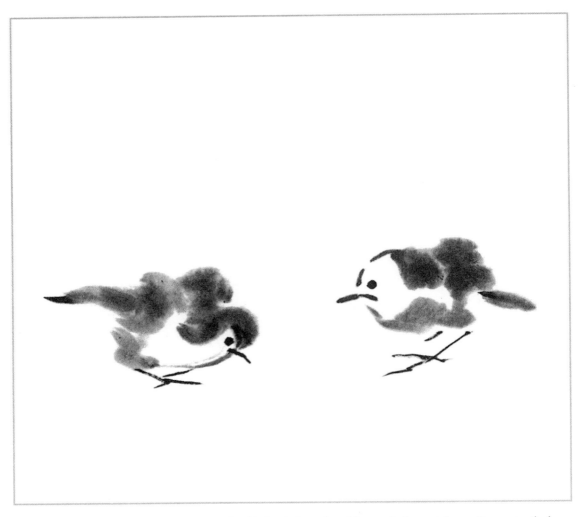

Plate 52. Baby birds. Soft and quick touch is used here. Contrast of dry, sharp strokes of tip of brush and wet areas made by side of brush.

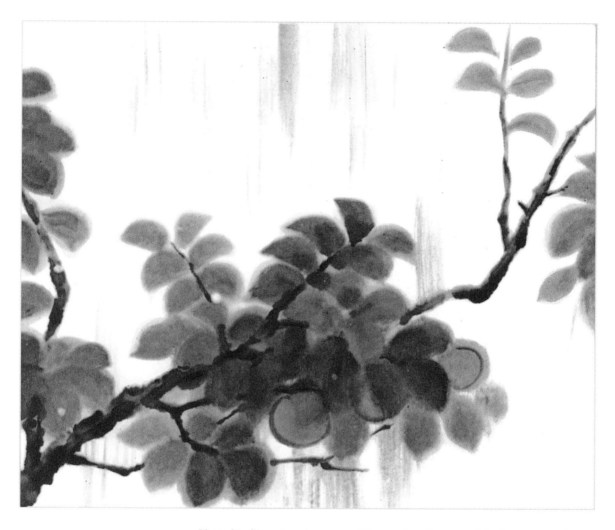

Plate 53. Tree in the rain. Wet, soft effect needed for rainy, foggy scenes. Everything is softly rounded, damp, running—a little color added while ink is still damp. Darkest accents delayed until painting is almost dry.

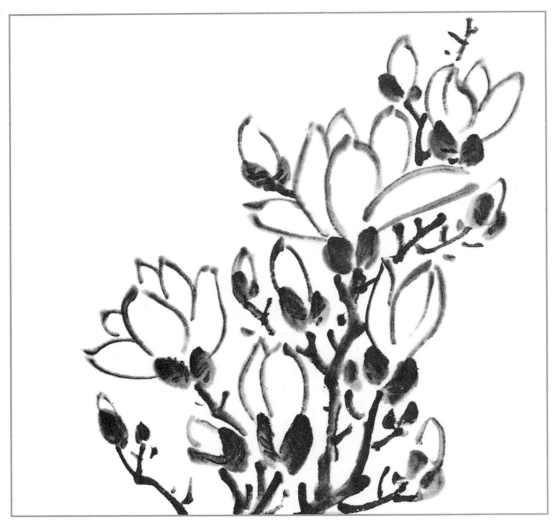

Plate 54. Magnolia. Magnolia petals in line (tip of brush) and leaves in wet rendering (side of brush)

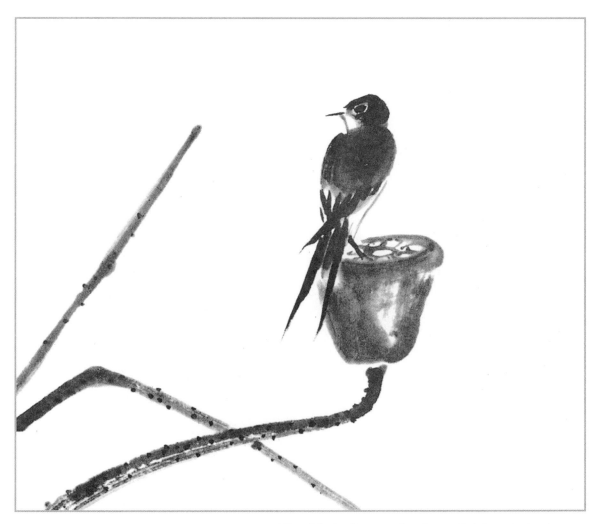

Plate 55. Swallow on dry lotus. Quick and simple composition using few strokes. First the bird. with wet areas painted in *bokashi* technique; then lotus pod; then stems.

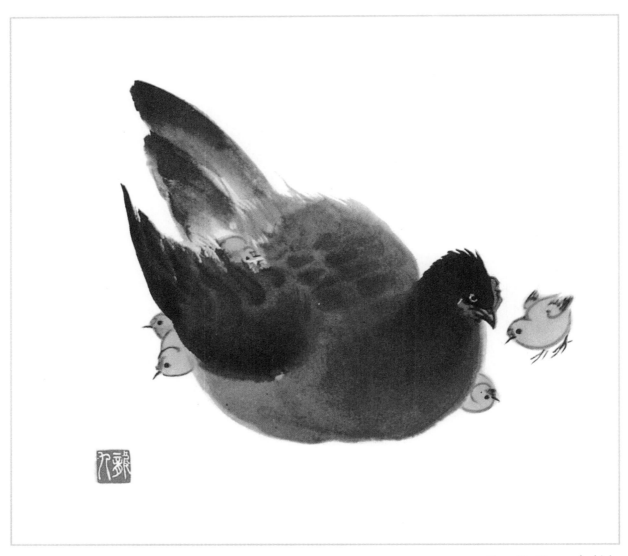

Plate 56. Hen and chicks.

PART SEVEN

Exemplars:

1. PAINTINGS BY
CLASSIC MASTERS

The following section presents three groups of paintings in suiboku style: paintings by classic masters of China and Japan, by the author, and by the author's pupils. The student can identify in these examples of suiboku the various techniques discussed in the text.

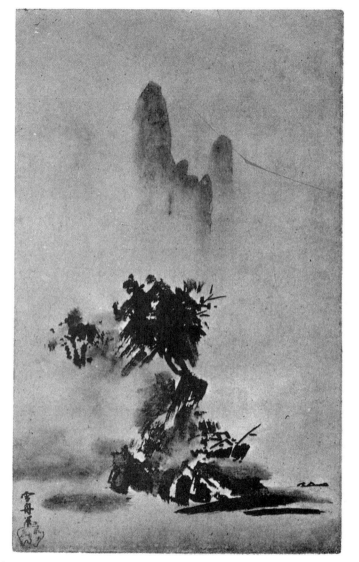

Plate 57. Landscape (detail of a hanging scroll), by Sesshu.

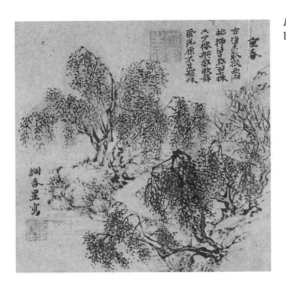

Plate 58. Landscape,
by Buson.

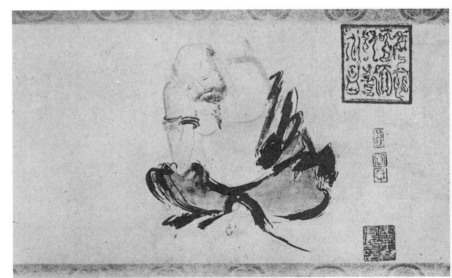

Plate 59. Zen Monk in Meditation (detail of a hanging scroll), by Shih K'o.

Plate 61. Landscape, by Mi Fei.

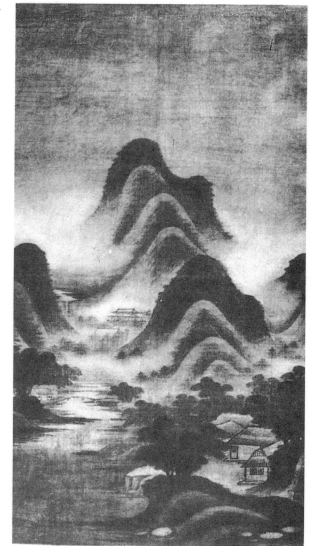

Plate 60. Puppy (detail of a hanging scroll), by Sotatsu.

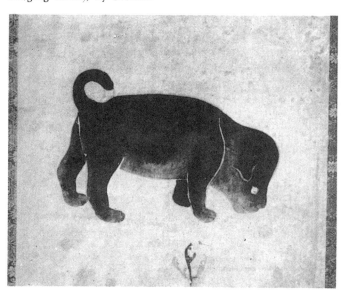

Plate 62. Landscape, by Taikan.

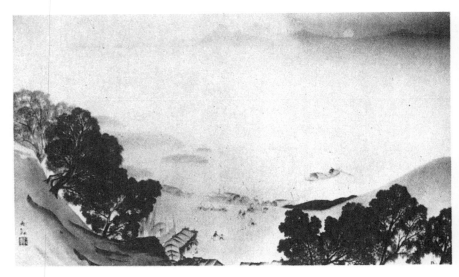

Plate 63. Pine and Waterfall (painted on *fusuma* or sliding screen), by Tessai.

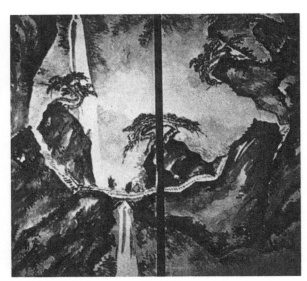

2. PAINTINGS BY THE AUTHOR

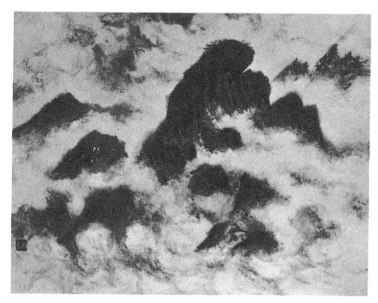

Plate 64. Sea of Clouds.

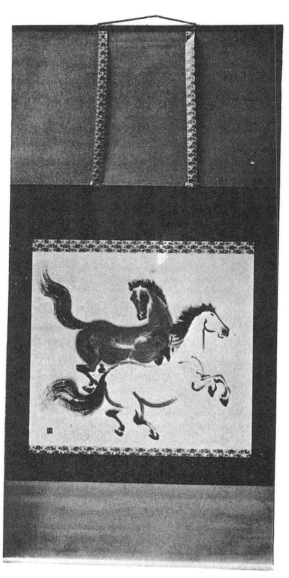

Plate 65. Horses (mounted in traditional kakemono manner)

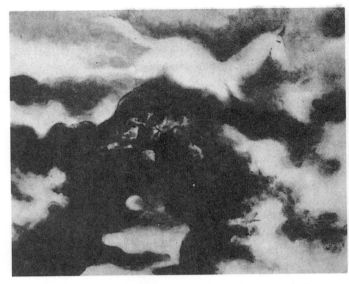

Plate 66. Stone Image in a Cavo.

Plate 67. Dream Ride.

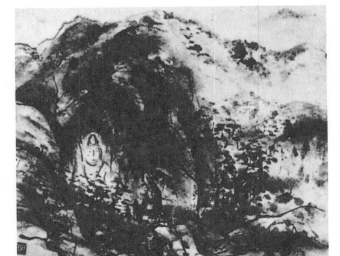

3. PAINTINGS BY
THE AUTHOR'S PUPILS

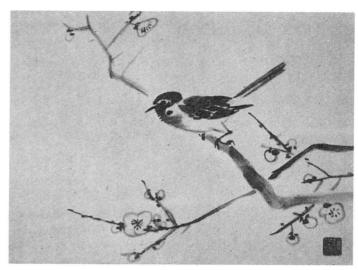

Plate 68. Bird on a Plum Tree, by Adeline Keller.

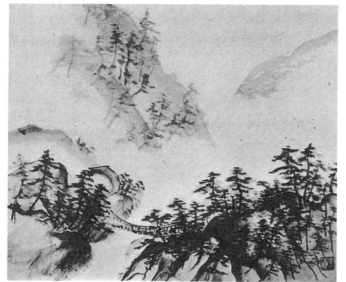

Plate 69. Landscape, by F. W. Eastlake.

Plate 70. Siamese Cat,
by Alice Innes.

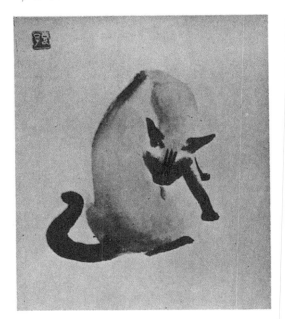

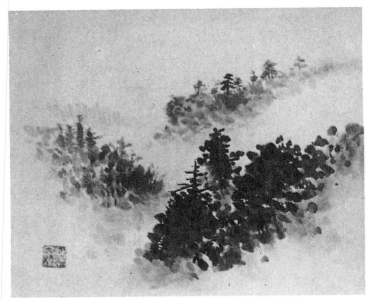

Plate 71. Evening,
by Hiroko Borish.

Glossary...

Akama-ga-seki: *suzuri* produced in Japan
bokashi: shading from dark to light contained in one brush-stroke
bokkotsu: (or *mokkotsu*) "without bones" technique
bokkotsu-hitsu: (or *tsuketate*) brush for all purpose both for calligraphy and painting
bunjin: men of letters
Buson: Japanese painter (1716–1783)
dei-enogu: thick water color
enogu: general term for water color
fude: (or *mōhitsu*) brush
fude-maki: small bamboo mat to hold the brush when not in use
gahitsu: brush for painting
gahōshi: type of Japanese handmade paper
gansai: (or *mizu-enogu*) thin water color
gasenshi: type of Japanese handmade paper for practice
gyokubansen: type of Japanese handmade paper
haboku: "broken ink" technique
hakutōshi: (or *wagasen*) Japanese paper used for practice (originally made in China)
hatsuboku: "splashed ink" technique
hōsho: type of Japanese handmade paper
hōuro: famous Chinese *sumi*
inzai: material for seals
iwa-enogu: hard color cake
kappitsu: "dry brush"; dry, broken or incomplete line
katsuboku: "give life to *sumi*"
kei: orchid with many flowers on one stem
keisan: paper-weight
kiku: chrysanthemum
kosaji: small spoon
kumadori-fude: short, round brush for outline work
madake: variety of bamboo
mensō-hitsu: brush for delicate lines
Mi Fei: Chinese painter (1051–1107)
mizu-enogu: thin water color (see *gansai*)

95

mōhitsu : brush (see *fude*)

mokkotsu : "without bones" technique (see *bokkotsu*)

mōsō : variety of bamboo

Nanga school : soft style of sumi painting (originated in China)

nembangan : a rock-like clay for making artificial stone *suzuri*

nijimi : water appearing as halo around the black *sumi*

nikawa . glue extracted from fish bones

nisōshi : type of Japanese handmade paper

Nobeoka-seki : *suzuri* produced in Japan

ran : orchid

saishiki-hitsu : brush for color painting

sakuyō : (or *sengaki-fude*) brush for outline or line work in general

seiboku : high blue-tone sumi

sengaki-fude : brush for line work (see *sakuyō*)

Sesshū : Japanese painter (1420–1506)

Shih K'o : Chinese painter (10th century)

shi kunshi : "four gentlemen" (basic *suiboku* subjects)

shohitsu : brush for calligraphy

Sōtatsu : Japanese painter (about 1570–1640)

suiboku-ga . ink and water painting

sumi : ink stick or black ink

sumi-e : painting done in sumi (general classification of ink-painting)

suzuri : inkstone ; stone for rubbing *sumi* or ink stick

Taikan : Japanese painter (1868–1958)

take : bamboo

tanchiku : variety of bamboo

tankei : natural stone found in North China for making *suzuri*

teikunbō : famous Chinese *sumi*

tentai : "spot and substance" technique

Tessai : Japanese painter (1837–1924)

tesuki : general term for handmade Japanese paper

torinoko : type of Japanese handmade paper

Tosa-tōshi : type of Japanese handmade paper

tsuketate : (see *bokkotsu-hitsu*) brush for all purpose both for calligraphy and painting

ume . plum

wagasen : (see *hakutōshi*) Japanese handmade paper used for practice (originally made in China)